FLORIDA

FLORIDA

THE SUNSHINE STATE

Michael Worek

Firefly Books

A Firefly Book

Published by Firefly Books Ltd. 2024
Copyright © 2024 Firefly Books Ltd.
Text copyright © 2024 Michael Worek
Photographs © as listed on page 110

All rights reserved. No part of this publication may be reproduced, stored in a retrieval system, or transmitted in any form or by any means, electronic, mechanical, photocopying, recording or otherwise, without the prior written permission of the Publisher.

First printing

Library of Congress Control Number: 2024935778

Library and Archives Canada Cataloguing in Publication
Title: Florida : the sunshine state / Michael Worek.
Names: Worek, Michael, author.
Identifiers: Canadiana 20240355903 | ISBN 9780228104803 (hardcover)
Subjects: LCSH: Florida—Guidebooks. | LCSH: Florida—Description and travel. | LCGFT: Guidebooks.
Classification: LCC F309.3 .W67 2024 | DDC 917.5904/64—dc23

Published in Canada by	Published in the United States by
Firefly Books Ltd.	Firefly Books (U.S.) Inc.
50 Staples Avenue, Unit 1	P.O. Box 1338, Ellicott Station
Richmond Hill, Ontario	Buffalo, New York
L4B 0A7	14205

Cover and interior design: Jacqueline Hope Raynor

Printed in China | E

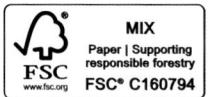

INTRODUCTION

FLORIDA
AT A GLANCE

Nickname:
The Sunshine State

Statehood: 1845; 27th state

Population (as of July 2023):
22,610,726

Capital: Tallahassee

Total Area: 65,758 square miles

Total Water Area:
12,133 square miles

Average Height Above Sea Level:
100 feet

Animal: Panther

Bird: Mockingbird

Flower: Orange blossom

Primary crops: Oranges, bell peppers, sugarcane, watermelons, cucumbers, grapefruit, strawberries, tomatoes and peanuts

Fact: The space industry represents $4.1 billion of the state's economy

Florida is famous for its sparkling beaches and almost constant sunshine. The sun and surf combine to attract spring breakers, vacationing families, celebrities, the newly retired and young people just starting out on their life and career.

But this state has much more than just an almost ideal climate to offer its residents and visitors alike. Major attractions include, among many others, Walt Disney World, Universal Studios, Busch Gardens, LEGOLAND and SeaWorld. The golf courses that are everywhere in the state provide a quieter escape for countless enthusiasts.

For those who love speed and adventure, Florida is home to the Daytona 500, as well as many classic car shows and motorcycle weeks. Boating opportunities here are second to none.

One of the most popular attractions in the state, the Kennedy Space Center, has been a liftoff point for space exploration since the 1960s. In total contrast is the vast wilderness and awe-inspiring plant and wildlife that fill the Everglades.

Florida's biggest cities — Miami, Tampa and Jacksonville — offer world-class museums and art galleries along with designer stores, trendy nightclubs and an almost unlimited number of bars and restaurants.

Despite its modern image, Florida also appeals to those interested in American history. St. Augustine, founded in 1565, is the earliest continuously occupied European settlement in the country. Antebellum plantation homes and live oaks draped in Spanish moss are favorite Florida sights, as are the 19th-century lighthouses that dot the coast.

You can find plenty of Art Deco architecture in South Beach, not to mention the grandeur of the state's period hotels such as the Breakers, and the mansions of the rich and famous who chose to make Florida their home.

The Sunshine State is a place of great activities, thriving cities and outstanding natural beauty — and the setting for all sorts of hidden treasures. Whether you're fortunate enough to live here or are just visiting, Florida has something for everyone.

Among all the attractions that Florida has to offer, none are more famous or more welcome to visitors and natives alike than its wonderful sand beaches and warm water. This beach in Miami is packed on a sunny day, yet there always seems to be room for one more.

The great white egret, one of Florida's most distinctive bird species, can reach three-and-a-half feet in height. Large numbers of egrets were killed in the late 19th century for their snow-white feathers, which were used to decorate hats. Today, the biggest threat to their continued survival is loss of habitat.

(Left) Majestic Antebellum plantation homes, like Gamble Mansion in Ellenton, Florida, were once found across the state. In their heyday before the Civil War, plantations produced rice, sugar and cotton. Today most of the remaining mansions function as museums or private homes.

The National Naval Aviation Museum is a military and aerospace museum located at the Naval Air Station in Pensacola. One of the largest aviation museums in the world, it features more than 4,000 artifacts and 150 aircraft used by the Navy, Marine Corps and Coast Guard. There are many hands-on displays, including flight simulators as well as IMAX films.

Pensacola is also famous for the Seville Historic District, where the Mary Turner Rule Cottage, shown here, is preserved. Mary Turner Rule began the campaign to preserve Pensacola's history and architecture, and the District is now a major attraction in the city.

Devil's Den Spring is one of the few world class natural wonders in the state that is privately owned. Located in Williston, the spring is found inside a dry cave. Fossils on the floor of the cave date back 33 million years to the Pleistocene Age. The water is crystal clear, as much as 50 feet deep, and at a constant temperature of 72 degrees, year-round. On cold mornings steam rising from the opening is clearly visible, which prompted early settlers to give the spring its name.

(Right) Florida Caverns State Park, located in the Panhandle near Marianna, offers tours of the cave to the public. This illuminated room in the cave provides a panoramic view of the stunningly beautiful stalactites, stalagmites and other fragile formations created over tens of thousands of years.

In 1824 Tallahassee was selected as Florida's state capital because it lay about midway between the state's two other major cities, St. Augustine and Pensacola. Tallahassee still offers plenty of Southern charm to delight the visitor. The Greek Revival Old Capitol building was completed in 1845; its 22-story modern replacement can be seen in the background behind the dome.

Florida State University is located in Tallahassee. Established in 1851, the university has continued to expand in size and prestige. Today nearly 45,000 students attend the school. The Westcott Building shown here was built in 1909.

Beaches are beautiful and inviting, but they are also very delicate natural environments. Besides protecting sea life and monitoring water quality, coastal communities must also maintain a system of sand dunes. *Ammophila* is the genus of the grasses we commonly refer to today as marram, bent or beachgrass. The roots of these plants anchor the dunes and protect them from erosion by wind and water.

(Right) By the 1820s the town of St. Marks, Florida, had become an important port. A lighthouse was completed in 1831 but erosion soon threatened the structure and it had to be dismantled and moved farther inland to its present location. The lighthouse suffered damage during the Civil War and underwent extensive reconstruction. Now inside St. Marks National Wildlife Refuge, it officially ceased operation in 2016 but is still used as a private aid to navigation for local boaters.

With so much coast, it's no surprise that Florida is a great place to look for shells. Shells are home to many species of sea life, and Florida has now banned the collection of shells that have a live animal inside. Shell Island Beach on the Gulf of Mexico, in the Florida Panhandle near Panama City, is a wonderful place to explore and look for shells.

(Left) Located just off Fort Myers, Sanibel Island is known as the seashell capital of the world. A wonderful day can be spent along its 15 miles of unspoiled beaches. There are also 22 miles of bike paths and lots of wildlife to see on the island. Construction on the lighthouse here was completed in 1884.

The Disney *Fantasy* docked at Port Canaveral is just one of many cruise ships that leave from Florida ports for destinations all over the world. The facilities aboard this 130,000-ton marvel include everything you would find at the finest resorts on land, plus offering the romance and adventure of being at sea.

(Right) Seminole Hard Rock Hotel and Casino dominates the night sky. Located minutes from Fort Lauderdale, the complex has over 450 rooms, a 5,500-seat concert arena and world-class gambling and dining facilities.

Fishing and eating fresh fish are some of the top attractions for visitors to the state. For trophy fish, a charter boat like this one trolling for sailfish off the Florida coast, offers the chance for the catch of a lifetime. For a more relaxed adventure, fishing from the pier is a favorite pastime.

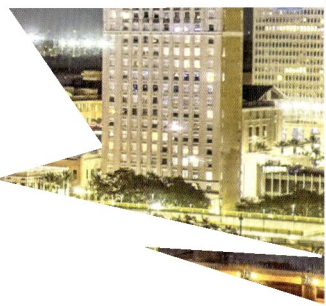

The Bridge of Lions in St. Augustine stands in stark and beautiful contrast to the modern span in Jacksonville. Florida is filled with both classical and modern architectural gems.

(Left) In recent years Jacksonville has become a major center for insurance and banking. The town was originally known as Cowford because cattle crossed the St. Johns River here. It was renamed in 1822 to honor Andrew Jackson, who had forced Spain to cede Florida to the United States two years earlier. Here the glowing lights at night highlight the Acosta Bridge that spans the St. Johns River.

Florida is a premier destination for anyone who wants to retire in a warm and sunny climate with plenty to see and do. The Villages, one of the most famous retirement communities in the world, is one of the fastest-growing metropolitan statistical areas in the United States. Located on 32 acres between Ocala and Orlando, The Villages has a population of approximately 80,000 people. Because this is an age-restricted retirement community, at least one member of each household must be 55 years or older. Transportation around the community, and to its many social and educational events, is by golf cart.

Hypolita Street, in the heart of St. Augustine's historic district, is home to bakeries, bed and breakfasts, galleries, and quaint shops. With its Spanish-style architecture, Old World charm and panoramic bay, it's easy to see why the city attracts so many visitors each year.

This aerial view of Ponce de Leon Hall of Flagler College in St. Augustine clearly shows the Spanish Colonial Revival style of architecture that is popular throughout the state. The building is designated a United States National Historic Landmark.

The St. Augustine Alligator Farm is a popular place to see one of Florida's most fascinating animals. It contains every type of crocodilian in the world, including rare Leucistic white alligators from Louisiana, miniature Chinese crocodiles and Nile crocodiles. There is also a Birds of Africa exhibit and a Native Reptile and Amphibian House. Tours and educational exhibits are offered daily.

The Lightner Museum in St. Augustine was commissioned by railroad magnate Henry Flagler and completed in 1887. The Chicago publisher Otto Lightner purchased the structure in 1946 to house his collection of Victoriana. Two years later the museum opened to the public.

(Left) The Spanish began work on the Castillo de San Marcos in 1672. The masonry fortifications were designed to replace the system of wooden forts that had defended the city previously. The Castillo resisted a two-month siege by the British in 1702, when the entire population of St. Augustine remained safe behind its walls. Now a National Monument and open to the public, it is a popular tourist attraction.

Each year Daytona Beach hosts Biker Week. Riders from all over North America make the annual trip to enjoy the warm welcome and beautiful beach.

(Left) The Daytona Beach Bandshell in Oceanfront Park, Daytona Beach is on the U.S. National Register of Historic Places. By day the bandshell provides an inviting backdrop to the famous beach. In the summer months, free concerts are held every Friday and Saturday night, with fireworks after the concert on Saturdays.

Ponce Inlet
LIGHTHOUSE museum

MUSEUM & GIFT SHOP HOURS
OPEN 10:00 AM UNTIL
LAST ADMISSION AT

This spiral staircase winds to the very top of the Ponce de Leon Inlet Lighthouse and Museum south of Daytona Beach. At 175 feet, it is the tallest lighthouse in the state, and one of the tallest in the country. The original structure was erected in 1835, but storms soon weakened the foundations and it collapsed. The lighthouse we see today was begun in 1883 and completed in 1887. Its oil lamp was replaced in 1909 with an incandescent lamp, and the lighthouse was electrified in 1933. The Coast Guard deeded the property to the Town of Ponce Inlet in 1972.

The Daytona 500, one of the most famous automobile races in the world, attracts thousands of fans every year to the Daytona International Speedway in Daytona Beach. The total prize money to be won in this grueling race is more than $28,000,000 dollars.

NASA's Space Launch System (SLS) rocket and Orion spacecraft, the Artemis I rocket, is ready to roll, fully prepared for its first journey to the launch pad at the Kennedy Space Center. A SpaceX Falcon 9 rocket (above) soars upward after lifting off from the launch pad.

COMMAND MODULE

SERVICE MODULE

The Visitors Center at Kennedy Space Center on Merritt Island is one of Florida's major tourist attractions. The enormous buildings are a tribute to the first decades of space exploration. In this room (above), the second stage engines of the Saturn 5 rocket that took the astronauts to the Moon is on display. The command module from Apollo 11 (left) is always popular with visitors.

The stunning architecture of the Orange County Convention Center in Orlando won it a special designation as one of the 100 most significant buildings in Florida in 2012. The center offers over 7 million square feet of space and hosts hundreds of events annually. It is the second-largest convention center in the United States.

The sparkling towers of modern Orlando rise above the waters of Lake Eola. The fourth-largest city in the state by population, Orlando is a constantly growing and rapidly developing center for the technology industries. Tourism, however, is still its economic anchor. There are more than 480 hotels offering 130,000 rooms in the city, with more being added each year.

The Entrance Arch welcomes visitors to Walt Disney World in Orlando, a magical place "Where Dreams Come True."

(Right) When Walt Disney World opened in Orlando in 1971, no one would have imagined how popular it would be, or that it would lead to the transformation of the entire area. Here beautiful fireworks light up the night sky over the castle in the Magic Kingdom.

Tarpon Springs is known as the sponge capital of the world. Greek immigrants began harvesting sponges here in the 1880s and it soon became a prosperous trade. Today, as much as 70 percent of the world's natural sponge harvest is estimated to come from Tarpon Springs.

Spanish moss is a flowering plant that grows most commonly on the southern live oak and other large trees in the southeastern United States. Spanish moss is often a favorite sight of visiting northerners. These trees are in Madeira Beach, a popular Gulf Coast community.

SeaWorld Orlando is another world-famous attraction in Orlando. SeaWorld offers a chance to see and enjoy aquatic life of all kinds, including penguins, sharks, dolphins and sea turtles. There are live shows and exhibits like this one where bottlenose dolphins are fed. The complex also features the tallest, fastest and longest roller coaster in Florida. More than 4 million people visit SeaWorld each year.

Although tourism is now Florida's largest industry, oranges remain an important part of the economic life of the state. Known for their sweet taste and juiciness, oranges and orange juice production contribute over 7 billion dollars a year to the state's economy and are enjoyed by residents and tourists alike. The Orange Shop in Citra provides a nostalgic reminder of the many roadside orange stands that were popular in the 1950s and 1960s.

The Disney monorail glides past Spaceship Earth, just one of the many family attractions at Walt Disney World's EPCOT theme park in Orlando.

(Right) Kissimmee (pronounced "kiss SIM mee"), located in the heart of the state, was incorporated as a city in 1883. The peaceful beauty of the surrounding area charms residents and visitors alike, and the Old Town Amusement Park features a Ferris wheel, carnival rides, shopping and fun for everyone.

Thank you
for Visiting!
Please come back again soon.

OLD·TOWN

SHONEYS
TICKETS

The pastel pink Don CeSar Hotel in St. Pete Beach was a favorite destination of the pampered rich during the Jazz Age. The hotel opened in 1928 but, after falling into disrepair, was converted into a hospital during the Second World War. The hotel reopened in 1973 and has undergone numerous renovations to bring it back to its original splendor. The sprawling complex can still attract the rich and famous, but it is now a family-friendly resort with a kid's camp and pool.

A cruise ship (above) passes under the Sunshine Skyway Bridge, which stretches five-and-a-half miles across Tampa Bay and is built of concrete with steel supports. Construction of the second span was completed in 1987, replacing the original 1950s bridge and its 1970s addition. An earlier bridge was partially destroyed when the freighter Summit Venture collided with the bridge during a storm in 1980.

(Right) Key West is a favorite port of call for many cruise lines because of its rugged beauty and famous residents. However, its relatively narrow, shallow waters and close proximity to coral reef ecosystem habitats leave Key West vulnerable to environmental risks from the cruise industry. Recent regulations have limited the size and number of ships allowed to visit Key West.

When you start to see flamingos, you know that you've reached Florida. There are four species of these beautiful, large pink birds in the Americas. They can reach three to five feet in height and can live for over 20 years. A group of flamingos is called a flamboyance.

Busch Gardens in Tampa was built in 1959 as a hospitality facility for the Anheuser-Busch brewery. After the plant closed, the site was further developed and is now a popular tourist attraction that is open to the public. Here giraffes take lettuce leaves from people visiting the gardens.

Bok Tower Gardens located north of Lake Wales is a National Historic Landmark. The massive project of developing the gardens was begun by Edward Bok, editor of *Ladies Home Journal*, in 1921. On February 1, 1929 President Calvin Coolidge dedicated the neo-Gothic Singing Tower carillon, one of the world's great carillons, with 60 bronze bells. More than 23,000,000 people have visited and enjoyed the popular attraction.

(Left) The John and Mable Ringling Museum of Art in Sarasota is housed in this Venetian-style palace. It was built in 1926 for John Ringling, one of the five original members of the famous Ringling Brothers Circus, and his wife, Mable. The couple assembled a significant art collection and, after their deaths, the estate was bequeathed to the people of Florida. After years of neglect both the artworks and the mansion have been restored to their former glory and the site is now a popular tourist attraction.

Fort Clinch State Park on Amelia Island covers over 1,400 acres. The fort is one of the best-preserved historic defensive structures in the nation. The site has been occupied by military troops since at least 1736, but work began on the familiar pentagonal walls in 1847. In addition to the fort, the park features an unspoiled natural environment for many species of plants and animals including the gopher tortoise and painted buntings.

Amelia Island is also home to the famous Amelia Island Lighthouse on Fernandina Beach. Built in 1838 it is the oldest surviving lighthouse in the state. It dates back to the years before Florida became a state and has survived without significant alteration. The City of Fernandina Beach now owns the building and tours of the building are a popular attraction.

Fort Myers, the commercial center of Lee County, is known for its sandy beaches and beautiful sunsets. Popular attractions include the mansions built by two of America's most famous inventors: Henry Ford and Thomas Edison, who made this beautiful area their winter home.

The observation tower at Shark Valley is one of the most popular places to begin a visit to Everglades National Park. Despite its name, there are no sharks inhabiting the valley; it is named for the Shark River. Sawgrass (*Cladium jamaicense*) is the dominant vegetation. During the rainy season, the area is often called a river of grass. Wildlife abounds in this important wilderness area. Alligators, ibis, wood storks, roseate spoonbills, raccoons, white-tailed deer and various amphibians are often seen.

(Right) No one described the magic of the Everglades better than President Harry S. Truman: "Here are no lofty peaks seeking the sky, no mighty glaciers or rushing streams wearing away the uplifted land. Here is land, tranquil in its quiet beauty, serving not as a source of water, but as the last receiver of it. To its natural abundance we owe the spectacular plant and animal life that distinguishes this place from all others in our country."

The American alligator is found everywhere in Florida. These fearsome but wonderful creatures, native to the southern United States, average between 11 and 14 feet long. Florida is thought to have a population of well over a million alligators. Look closely at this image taken in Everglades National Park and you'll see there is a baby alligator sitting on the mother alligator's head.

(Left) Airboat tours are a popular way to explore the Everglades. Because the water is shallow and the underwater vegetation thick, regular power boats cannot penetrate the interior of the park. Airboats slide over the surface of the water and vegetation without disturbing the natural environment.

In 1896 Standard Oil executive Henry Flagler built the Palm Beach Inn. He soon more than doubled the structure's size and renamed it The Breakers after guests continued to request rooms "over by the breakers." In 1903, during one of several expansion projects, the hotel burned to the ground. A year later it reopened to critical acclaim; guests such as the Rockefellers, the Vanderbilts, American presidents and European royalty have all stayed here. It continues to be a luxury resort that attracts the rich and famous.

(Left) Notable for its modified 15th-century Gothic design, Palm Beach's Episcopal Church of Bethesda-by-the-Sea was the first Protestant congregation in southeast Florida when it was established in 1889. The current structure, finished in 1925, has been the site of several high-profile weddings, including that of President Donald Trump and wife Melania.

Miami's famous Art Deco architecture takes on extra appeal when finished with bright and happy neon colors. Modern buildings like this one (right) take the classic Art Deco style and give it a modern twist, capturing the best of both worlds. Even this lifeguard tower (above) on South Beach continues the theme.

Hotels and restaurants line Ocean Drive in South Beach, one of the most iconic parts of Miami's Art Deco heritage areas.

A classic Pontiac convertible from the 1950s looks right at home parked in front of the Avalon Hotel on Ocean Drive in South Beach.

Miami Beach is a popular destination for locals and tourists. The beach developed into America's Riviera during the 1950s. Since the late 1980s it has experienced a dramatic rejuvenation, and the Art Deco architecture now helps to make it one of the premier vacation destinations for people all over the world. At night the bars and restaurants (above) are packed with people enjoying the food, excitement and music.

The annual Miami International Boat Show in February attracts more than 100,000 visitors and buyers from around the world. Every conceivable boat, as well as the latest water sports attractions, are on display. The Venetian Causeway Staging Area (above) is packed with people and products every day during the show.

Florida's climate, warm and sunny all year round, makes it a wonderful place for boating. Although powerboats and fishing boats abound, the quiet pleasure of sailing back to port at sunset after a day on the ocean is hard to beat.

(Right) Classic cars and car shows are a popular attraction. This beautiful red 1929 Auburn 120 Speedster is on show at the 32nd Annual Naples Depot Classic Car Show, to the delight of visitors.

The Tampa Bay Buccaneers of the National Football League are based in Tampa. The Buccaneers have won two Super Bowl championships and are the first post-merger expansion team to clinch a division title. Florida's other NFL teams are the Miami Dolphins and the Jacksonville Jaguars.

(Left) Hard Rock Stadium is located in Miami Gardens. It opened in 1987 as Joe Robbie Stadium and had been known by several names before the Hard Rock Cafe purchased naming rights in 2016. It is the home field for the Miami Dolphins of the National Football League. The stadium has also hosted six Super Bowls, two World Series championships and the annual Orange Bowl.

The Biltmore Hotel opened in 1926 and was the place to be during the Jazz Age. From the very start it was one of the grandest resorts in the country. It contains a 400-room hotel, a country club with an 18-hole golf course, polo fields, tennis courts and an enormous swimming pool. During the Second World War it was converted into a hospital. The city of Coral Gables acquired ownership in 1973 and 10 years later it reopened, restored to its former glory.

(Right) The Fairchild Tropical Botanical Gardens, named after the botanist David Fairchild, is an 83-acre paradise located in Coral Gables. The gardens were designed and constructed in 1936 by Roger Montgomery and today attract thousands of visitors each year.

Jurassic Park, part of Universal Orlando Resort's Islands of Adventure theme park, takes visitors into all the wonder and excitement of the famous movie franchise. Universal Studios Orlando is visited by more than 10 million people a year.

Fort Jefferson is a major attraction within Dry Tortugas National Park on Garden Key in the lower Florida Keys. The fort is the largest brick structure in the United States. It covers 16 acres and over 16 million bricks were used in its construction. In 1935 the area was designated as a National Monument. The Dry Tortugas, including Fort Jefferson, were established as a National Park in 1992. The fort can be reached by ferry from Key West.

(Left) The 65-foot-tall Boca Chita Key lighthouse in Florida's Biscayne National Park was built in the 1930s to guide pleasure boats into the harbor and to be an attractive addition to the area. Biscayne National Park, accessible only by boat, is made up of coral reefs, islands and shoreline mangrove forest in the Florida Keys. Dolphins, pelicans and turtles live in Biscayne Bay Lagoon. The underwater Maritime Heritage Trail links dive sites, most of them shipwrecks.

Duval Street is the most famous street in Key West. Tourists on the famous Key West Conch Train pass the Whistle Bar as they tour the area (left). The interior of Sloppy Joe's Bar (above), also on Duval Street, was made famous by Ernest Hemingway, who gave the place its name.

St. Paul's Episcopal Church in Key West was formed by an official act of the City Council of Key West in 1831. The first service was held on Christmas Day 1832 in the County Courthouse on Jackson Square. Construction of the current building was begun in 1919 and the church remains an active part of the community today, welcoming all residents and visitors.

Ernest Hemingway's home in Key West attracts visitors from around the world. Hemingway lived in the Spanish colonial style villa with a tropical garden around it from 1931 to 1939. He wrote *For Whom the Bell Tolls* and *To Have and Have Not* in this house.

The Dolphin Research Center at Grassy Key is a working research facility focused on studying dolphins and sea lions. The Center offers interactive exhibits and an ideal chance for visitors to see and learn about these intelligent animals.

(Left) Manatees always make for a welcome sight along Florida's rivers, waterways and coastal waters. Officially classified as a threatened species, they have even been pictured on license plates to support research and conservation efforts.

Lion Country Safari in West Palm Beach offers a drive-through exploration of an African savannah. There are large herds of giraffes, zebras, rhinoceroses and more, all free to roam through the park. There are also walk-through areas where you can hand-feed giraffes as well as educational presentations and rides for children.

The boardwalk at the Anne Kolb Nature Center in Hollywood leads through 20 acres of coastal mangrove wetlands rich in native plants and animals, including many threatened and endangered species. The Center includes an exhibit hall, a 3,500-gallon aquarium, a fishing pier and a 68-foot observation tower.

Ravine Gardens State Park in Palatka was created during the 1930s to provide jobs and protect the environment. There are two ravines 120 feet deep, with steep banks at 45-degree angles, that can be explored using the trails and bridges. The park is especially famous for its 18 different types of azaleas, which bloom from January to March.

(Right) Falling Waters State Park in Chipley contains many fern-covered sinkholes and Florida's highest waterfall, which drops 73 feet, all accessible using the trails and boardwalks. There is an overnight campground in the park and a beautiful butterfly garden that makes a visit here a serene and beautiful experience.

Since opening in 1977 the Morikami Museum & Japanese Gardens in Delray Beach has been a center for Japanese arts and culture in South Florida. There are rotating exhibitions, tea ceremonies performed monthly (October through May), and Japanese traditional festivals, which are open to the public.

The Phillip and Patricia Frost Museum of Science in Miami sits on four acres of beautiful bayfront land. There are six floors of interactive exhibitions dedicated to the ecosystem of the Everglades, as well as a 500,000-gallon aquarium and the world-class Frost Planetarium, which seats 250 people.

A blue-and-yellow Macaw, one of Florida's many colorful avian inhabitants, watches visitors at the Central Florida Zoo and Botanical Gardens in Sanford.

(Left) LEGOLAND Florida Resort in Orlando is dedicated to kids from ages 2 to 12. Its more than 50 rides, shows and attractions are all inspired by LEGO characters. The water park, the Peppa Pig Theme Park and the botanical gardens complete this unique family attraction.

The zebra longwing butterfly, *Heliconius charithonia*, was designated the state butterfly in 1996. Found throughout Florida, it is especially common in the Everglades. Longwing caterpillars eat the leaves of passion flowers that contain a toxin that gives the butterfly an unpleasant taste and makes it poisonous to predators.

(Right) Navarre Beach, located in one of the most beautiful areas of the Florida Panhandle, proudly proclaims itself as "Florida's Most Relaxing Place."

WELCOME TO
Navarre Beach
FLORIDA'S MOST RELAXING PLACE

PHOTO CREDITS

ALAMY

Jeffrey Isaac Greenberg 16+: 10; M. Timothy O'Keefe: 19; Charles LeRette: 26; Sipa USA: 42; AndKa: 45; Shawn.ccf: 49; Jeffrey Isaac Greenberg 2+: 50; Helen Sessions: 56; Alex Gore: 60; VIAVAL: 63; Prisma by Dukas Presseagentur GmbH: 64; Ian Dagnall: 95; Stephen Saks Photography: 99

SHUTTERSTOCK

fotomak: cover, 4; Nicole Glass Photography: 2; romarti: 5; Rainer Lesniewski: 7; Brocreative: 8; Worachat Sodsri: 9; FloridaStock: 11; James Kirkikis: 12; James Kirkikis: 13; ADRIAN DIAZ CADAVID: 14; A Cotton Photo: 15; NayaDadara: 16; Feng Cheng: 17; Mark Winfrey: 18; Daniel Korzeniewski: 20; Darlene Stanley: 21; Joni Hanebutt: 22; Bilanol: 23; Lee Reese: 24; Rolando Otero: 25; ESB Professional: 27; Kim Lewis Photography: 28; Jillian Cain Photography: 29; lazyllama: 30; Wangkun Jia: 31; James M. Chambers: 32; JennLShoots: 33; Wangkun Jia: 34; Kristi Blokhin: 35; VIAVAL TOURS: 36; SandiMako: 37; Dennis MacDonald: 38; Ronald Sherwood: 39; Grindstone Media Group: 40-41; Blueee77: 43; NaughtyNut: 44; CrackerClips Stock Media: 46; Andriy Blokhin: 47; VIAVAL TOURS: 48; Jeff Kinsey: 51; VIAVAL TOURS: 52; VIAVAL TOURS: 53; Joanne Dale: 54; Astrid Gast: 55; JHVEPhoto: 57; RandomHartz: 58-59; Ovidiu Hrubaru: 61; perlphoto: 62; Sean Pavone: 65; iofoto: 66; Henryk Sadura: 67; FloridaStock: 68; Philip Lange: 69; Andy Lidstone: 70; Don Fink: 71; GagliardiPhotography: 72; Vlad G: 73; Wangkun Jia: 74; Sean Pavone: 75; Mia2you: 76; Ivan Cholakov: 77; Khosro: 78; zimmytws: 79; GagliardiPhotography: 80; Kamira: 81; Felix Mizioznikov: 82; Felix Mizioznikov: 83; Artiom Photo: 84; SunflowerMomma: 85; YES Market Media: 86; Katherine Welles: 87; Fotoluminate LLC: 88; mariakray: 89; Mike Van Moonlight: 90; VIAVAL TOURS: 91; Nicole_N: 92; Varina C: 93; Stuart Monk: 94; Claude Huot: 96; Petr Kahanek: 97; Thierry Eidenweil: 98; mariakray: 100; jaimie tuchman: 101; Justgofamily: 102; William Silver: 103; Jean Prado R75: 104; EQRoy: 105; EQRoy: 106; Archaeopteryx Tours: 107; rorue: 108; Andriy Blokhin: 109; BlueBarronPhoto: 112

INDEX

Acosta Bridge, 26
Amelia Island, 66–67
Amelia Island Lighthouse, 67
Anne Kolb Nature Center, 101
Avalon Hotel, 79
Biltmore Hotel, 88
Biscayne National Park, 92
Boca Chita Key Lighthouse, 92
Bok Tower Gardens, 65
Breakers, 5, 75
Busch Gardens, 5, 63
Castillo de San Marcos, 34–35
Central Florida Zoo and Botanical Gardens, 107
Daytona Beach, 36–41
Devil's Den Spring, 14
Dolphin Research Center, 99
Don CeSar Hotel, 58–59
Dry Tortugas National Park, 93
Episcopal Church of Bethesda-by-the-Sea, 74–75
Ernest Hemingway, 95, 97
Everglades, 5, 70–73, 105, 108
Everglades National Park, 70–73
Fairchild Tropical Botanical Gardens, 88–89
Falling Waters State Park, 102–103
Fernandina Beach, 67
Florida Caverns State Park, 14–15
Florida State University, 17
Fort Clinch State Park, 66
Fort Myers, 20–21, 68–69
Gamble Mansion, 10–11

Hard Rock Stadium, 86–87
Hypolita Street, 30
Jacksonville, 5, 26–27
John and Mable Ringling Museum of Art, 64–65
Kennedy Space Center, 5, 42–45
Key West, 61, 93–97
Kissimmee, 56–57
Lake Eola, 47
LEGOLAND Florida Resort, 5, 106–107
Lightner Museum, 35
Lion Country Safari, 100
Madeira Beach, 51
Mary Turner Rule Cottage, 13
Miami, 5, 76–83, 105
Miami Beach, 76–83
Morikami Museum & Japanese Gardens, 104
Naples, 84–85
National Naval Aviation Museum, 12
Navarre Beach, 108–109
The Old Capitol, 16
Orange County Convention Center, 46
The Orange Shop, 54
Orlando, 46–49, 52–53, 56, 90–91, 106–107
Palm Beach, 74–75
Palm Beach Inn, 75
Panhandle, 14, 21, 108–109
Pensacola, 12–13
Phillip and Patricia Frost Museum of Science, 105
Ponce de Leon Hall, 31
Ponce de Leon Inlet Lighthouse, 38–39

Port Canaveral, 22
Ravine Gardens State Park, 102
Sanibel Island, 20–21
Sarasota, 64–65
SeaWorld, 5, 52–53
Seminole Hard Rock Hotel and Casino, 22–23
Seville Historic District, 13
Shark Valley, 70
Shell Island Beach, 21
South Beach, 5, 76, 78–79
St. Augustine, 5, 27, 30–33
St. Augustine Alligator Farm, 32–33
St. Marks National Wildlife Refuge, 18–19
St. Paul's Episcopal Church, 96
St. Pete Beach, 58–59
Sunshine Skyway Bridge, 60
Tallahassee, 16–17
Tampa, 5, 63, 87
Tampa Bay, 60
Tarpon Springs, 50
Walt Disney World, 5, 48–49, 56
West Palm Beach, 100
Westcott Building, 17

Eastern brown pelican